Gabriele Wohmann, born in 1932 in Darmstadt, is the author of stories, novels, and poetry. In all her work she has emphasized the relationship between private persons and the collisions they experience in society and reduplicate in their own lives. A very private person herself, she has learned nevertheless to meet inevitable encounters with society and to incorporate them in her fictional and poetic utterances. Her work is a valiant record of societal tentacles that reach into the most personal corners of the lives of families and lovers. The vital inner self of individuals is in constant peril from the onslaught of other selves. Her work is a microscopic examination of the intricate dance of selves on their way to oblivion.

Jeanne Willson has translated Friedrich Schiller's *Don Carlos* and his dramatic trilogy *Wallenstein*, Stefan Andres' gripping tale of the confrontation of art and implacable authority, *El Greco Paints the Grand Inquisitor*, Andreas Reichstein's history of early Texas, *The Rise of the Lone Star*, and Hans Bender's wrenching novel of wartime captivity, *The Mud Sled*.

The Cherry Tree

Gabriele Wohmann

translated by Jeanne Willson

The Dimension Press
1994

Copyright © 1994 The Dimension Press
 P. O. Box 26673
 Austin, Texas 78755-0673
 U.S.A.

Originally published by the Eremiten Presse,
Düsseldorf, under the title *Der Kirschbaum*, © 1984

First Edition

Library of Congress Cataloguing-in-Publication Data

Wohmann, Gabriele, 1932-
 [Kirschbaum. English]
 The Cherry Tree / Gabriele Wohmann ; trans-
 lated by Jeanne Willson.
 -- 1st ed.
 124 p. 14 x 21.5 cm.
 ISBN 0-911173-05-6 ; $16.95
 I. Willson, Jeanne. II: Title
PT2685.034K46 1994
833' . 914--dc20 94-14839
 CIP

Printed in the United States of America

The Cherry Tree

Every Wednesday Ingbert was enraptured anew by Sonja Spielberg's habit, when she served them, of lifting the lids from the bowls with a sort of dismay and by her sharp, surprised cries. Yes, she uttered little shrieks, his hostess did, like a bird who is warning the other members of the flock. Still, what she looked upon in the bowls and sauceboats and small compotes was nothing but delicacies. Actually, she cooked exquisitely, and Ingbert

wished he could be her guest for more than
the Wednesday meal. Could he possibly have
a chance? Dr. Kern enjoyed this advantage.
Four times a week he dined at Sonja Spielberg's.
Why really? What right had he? Ingbert had
never heard that more time was available than
Wednesday at noon.

Completely senseless to appear at her house
at the appointed time, and she admitted it
frankly, too. She said, "Come at one o'clock,
but you know, of course, I won't be ready."

"Isn't it absolutely gratifying to witness this
phenomenon—it is in fact a phenomenon—of
a woman of her age and background, too, who
knows how to put you at ease?" Mr. Truebner
asked without addressing anyone in particular.
He already had a very moist voice, for before
a meal it cost him some effort to control his
saliva. It often dripped from his lower lip, and
with a sucking sound Mr. Truebner drew the
moisture back onto his tongue; then he swal-
lowed. He had a round head with an eager,

flushed face. Because of a slight mix-up on the part of his Creator, he had become Mr. Truebner and not a watchful rodent inhabiting some forest. Dr. Kern, on the other hand, did not look transformed but as if by design a human being, pale and abstract. What a bunch we are, and how unabashed is the regularity with which we get an appetite time after time, thought Ingbert. Yet, as a matter of fact, he generally felt himself to be uncommon, removed in a significant but still inexplicable way from the abundant and unfortunate production of the human species.

As long as there were women like Sonja Spielberg, he could hold out on this cold, drafty earth. Such was the feeling once again of this chief administrative assistant, Ingbert Wagner, on a Wednesday that, aside from this cozy first-floor room, fragrant with things roasting, certainly impressed him as lusterless, even completely superfluous. All around outside, his fellow men frittered away the terms of their

existence, their very existences themselves, and the circumstances of their existence seemed like an insult, and they insulted people like Ingbert; yes, indeed, how cheerless all that really was. Sonja's activity in the kitchen could be depended upon to win him over. Here at her place the smell of food did not disturb him at all. But at his landlady's the greasy smell of long years of habitation and food preparation had either actually infiltrated the furniture in perpetuity, nestling there for the whole eternity of this place's existence, or the greasy smell was Ingbert's *idee fixe*, which resulted in the same annoyance. He smelled it all the time. He expected it when he turned the corner of Clinic Street two houses away from the entrance to No. 63a. He had a ventilator fan installed at his own expense; but since the service man would do only the usual and, because of a lack of imagination typical of the human race, refused to install the appliance in the living room, front hall, or

the bedroom instead of the bathroom, unless Ingbert commanded him to do so, Ingbert did not use the fan at all. Actually, the ventilator had long since been an annoyance to him. Hardly had he dared to enter the bathroom when a howling received him that sounded malicious or full of expectancy, depending on Ingbert's mood, and that only served the purpose of urging him to hurry up.

Dr. Kern had already been talking for quite a while about the six-hundredth anniversary celebration of Kreisstadt and had now proceeded to become abusive about the nonsense surrounding the expensive unveiling of a memorial statue.

For Ingbert hunger pains around noontime could sometimes turn into nausea, and he had discovered that this somatic phenomenon was due to noise. Especially noise that carried informational merit. Much was dependent on this noonday sensitivity for the preservation of his health, which in turn was responsible

for the state of Ingbert's disposition, and for
that reason he now intervened. He lamented:

"Look here, my good doctor, you're in a
talkative mood today, you're in a good humor
perhaps. I assume that on the days of the week,
when it is not granted me to examine your
state of mind, you might be afflicted by spells
of taciturnity or lassitude occasionally...just
as I..."

Mr. Truebner interrupted him: "I esteem
your love of tradition. You haven't accepted
that newfangled renunciation of the value of a
polished syntax yet. Bravo!"

Mr. Truebner had retired years ago as senior
assistant schoolmaster in the fields of German
and history, and so he fed his passion for
language and pedagogy at a small flame by
tutoring.

"But I," Ingbert continued, and he mas-
saged the place under his shirt where his
malady lay, namely, the area of stomach and
gall bladder, "but I'm not in a good humor

today. I am having an uncommunicative day, a supersensitive day, a totally vulnerable, absolutely horrible day."

He knew that he was scarcely even exaggerating. But now, fortunately, Sonja Spielberg finally appeared, and Ingbert's condition was still reversible. How much he appreciated her custom of pushing open the door to the dining room with her crooked arm; diagonally, the full tray in both hands, she worked her way to the dining table.

"Come to the table, come to the table," instead of Sonja, Dr. Kern called out. Ingbert found that very improper. It was not his business, not Mr. Truebner's either, it was nobody's business but Sonja Spielberg's, to invite them to the round table, to urge them on to the meal, not even *bonne appétit*, thought Ingbert—and perceived precisely, proud of himself, too, what a very sensitively constructed soul he really was—not any one of them except for their hostess ought to wish the others even

bonne appetite. Humbly we should bow our heads, thought Ingbert.

The two Spielberg sisters did not make a fetish of their valuable antique furniture pieces. Ingbert had found entrance to this pleasant house through Maria Spielberg. The fact that bowls, for which there was no more room on the table, were put down within reaching distance, some on the writing space of a Biedermeier rolltop desk made of distressed cherry wood, some on the late-nineteenth-century etagere, showed a lack of solicitude for furniture that, however, in Ingbert's eyes, only made possible a special form of solicitude. Solicitude for sociability, regard for human companionship, he thought, and if he had not been forced to regret as always on Wednesdays the lack of time between this conversational circle and Sonja's serving for what he called *hand washing,* which the others obviously did not require, then a moment of almost complete satisfaction would have existed for him now.

He watched Sonja Spielberg's actual prelude now. Self-conscious or perplexed, what was she, really, what, when she might have felt completely secure after all, since a dish had never yet failed her. Ingbert was glad that her cooking was plain, not punctual to the minute; every time she was like a young girl attempting her first public soufflé. Dismayed she looked into the bowl, she watched Mr. Truebner's spoon as it groped around in it—Mr. Truebner was helping himself; Sonja's face was flushed and tinged with moisture, she half stood up again as if she had forgotten something or other, and probably she had forgotten something. She seemed still to be moving in a current that was alien to the table circle.

At this point Ingbert, who had still not tasted anything, but had allowed a panoramic view of his plate to take place as a quasi substitute for the saying of grace—wasn't that proper and why did the others fail to observe this little impressive moment?—and actually,

after a tiny cough, he said that it was good; "it is delicious," that's the way he usually expressed himself, with the hope that his thanks and something like the consciousness of his own guilt would be insinuated by his praise. Expressing thanks! It was really onerous for him. Perhaps this feeling of annoyance occurred because he required too much fervor of himself. And besides, he paid his obolus, so why the excess?

"Really? It's really good, is it? It'll do after a fashion?" Sonja spoke to herself in an undertone, disparagingly, she acted disbelieving. Then she took a small piece of the roast beef herself on the tip of her fork.

"It was better when I made it in nineteen-hundred-I-don't-remember-when in Dargun that time. It's good. That's true," she said.

Only now did Maria Spielberg appear at the table. The men welcomed her distractedly. None of them had any desire to waste time at the beginning of the meal. Maria looked

excited and resplendent. She had a brief, fast
walk with her Labrador, Alaska, behind her;
and after everything had been taken care of
between her and Alaska, an inner mystery
animated her, personally inaccessible to other
people. Maria ate only what she could put in
her mouth with a fork or with a spoon and one
hand, and she always found a little something
already cut up; her sister Sonja furnished her
with it, and so Maria ate with her left hand,
her right hand always on the dog in silent
competition with Sonja, who enjoyed feeding
the dog in secret as much as some people do
the furtive, urgent scratching of a mosquito
bite, under the table, somewhere near the knee.
Alternately she praised and criticized the meat,
rice, endive, only the gravy remained without
dispute in her favor.

"And yet I'm restraining myself, yes, my
dear, I am, despite your gravy, which is without
doubt particularly well prepared," said Mr.
Truebner. "No thanks, no thanks. With regret,

certainly, but here my renunciation must be radical. My gall bladder is not what it used to be."

"I, on the contrary," said Dr. Kern, "owe it to your cooking, my dear lady, that I'm able to enjoy eating and drinking again without very much difficulty."

He was forced to continue the talk about drinking for a while, until it occurred to both Spielberg sisters—and both were shocked as if by thunder and lightning, startled into increased girlishness—that nothing to drink had been served. Forgotten! Forgotten once again! Sonja cursed herself gently, while Maria, along with Alaska, who jumped around her legs in a disorderly fashion, ran into the kitchen at once and returned with a bottle of white wine in one hand and a bottle of mineral water in the other.

"Or would you rather have plain water?"

Naturally the gentlemen, with the exception of Ingbert, wanted plain water. Ingbert

cleared his throat and took care that it appeared put on. He hoped the sisters understood that this clearing of the throat was a reproach directed at his table companions.

"For me it's solely a matter of the indelicate consequences resulting from the consumption of carbonated beverages," said Mr. Truebner. Now, after his first hunger had been appeased, he became even more solemn. "A feast for the palate, again every time. My dear Sonja, I do not hesitate to call you a sorceress."

In reference to food, even though it was actually excellent, this was an exaggeration, Ingbert found, ridiculous, he thought, but by calling it sorcery he is not at all so wrong, the old boy. Really annoying how seldom he managed to produce a suitable compliment himself. Now he had a desire to converse a little about the frequent use, that deplorable necessity, of the little word "really." Something clever would have to occur to him before they went on to dessert. Ingbert wanted to make an

impression in general, but also perhaps on each
one in turn, and the first in line was Sonja
Spielberg. But he particularly wanted to please
the man, a little the color of smoked eel, in
the mirror at the back of the china cabinet.
His face among the cups did not please Ingbert
enough when it was animated by the business
of chewing. Why did pressure points appear
on his chin from chewing? His face looked
vulnerable then, anxious, but why? No reason.
So much more urgent then to pull his face
together by means of a distinctly intellectual
announcement. Careful consideration would
prove to be of benefit to his face. On the one
hand it was fortunate that the mirror was tinted
a brownish color; on the other hand this remin-
der of the smoked fish department of a grocery
store disturbed him every time. That was his
face. He had never really been in favor of
changing places with Dr. Kern or Mr. Truebner.
Was anyone aware of his secret and knew that
he looked at himself so often, as often as pos-

sible, in spite of every disappointment? I like
my own company, he had previously remarked
once in this circle around Sonja Spielberg and
afterwards, almost immediately, regretted it
terribly. It sounded, when he repeated the re-
mark in his mind, exasperatingly silly. Possibly
he got it from his landlady, a determined and
at times affected person who considered her-
self to be admirable simply because she had no
organic infirmities and yet was already sev-
enty-eight years old.

Ingbert appreciated Sonja Spielberg, among
other things too, because she was a bit old-
fashioned in her dress. By way of example, she
wore no pant suits.

His landlady wore pant suits. Ingbert sus-
pected this stalwart, intrepid woman of using
a false last name. Her original name could not
be Taxis. Thea Taxis. Probably her choice of
alliteration and aristocratic veneer went back
to the former period of her life, when she had
distinguished herself as the author of books for

young girls: She talked about that on occa-
sion. This morning she had looked robust and
ready in a pant suit of walnut creme beige and
a material that was too clinging as Ingbert had
crossed her path or, rather, her effort, expended
in great strides, to miss neither Streetcar Num-
ber 9 nor one minute of this, only in her reso-
lutely optimistic eyes, coldly illuminated,
wonderful, February day. All the same, Ingbert
had asked his landlady, whom he did not often
meet, how she was. He pretended to be in a
hurry, waved three pieces of mail in the air,
and he gave his physiognomy orders to signal
happiness and cheer. Happiness about this
meeting here between the streetcar stop and
the apartment building, Number 23, on Ernst
August Boulevard.

"How am I?" she had bellowed at him. The
noise of the traffic increased as the light
changed from red to green. "Well, I'm fine,
just fine. I have no big aches and the little
ones, you keep those to yourself. Right?"

"I don't know," Ingbert called after her, but she had gone on without interruption.

In the eyes of his landlady, of course, a person like him, plainly lived on the "little aches"; not at all so stupid, the role of that confident sort of person who on a sunny February morning has already found in some place or other the very first spring bud and on the first of December is already wishing other people, and as a precaution rather gloomy people, Merry Christmas. However, after that short meeting his little aches did not depress Ingbert, but on the contrary his exasperation at the landlady was useful to him, and he comforted himself with his deep-sea provender, those unpretentious burdens, "little aches," that made up his existential fabric. Yes, indeed, she was damned right if she really put him in his place, a region deep below where he dipped down for sustenance under all the surface water. Ingbert had sometimes eaten a cold supper at his landlady's and also infrequently

afternoon tea with unfashionable pastries, dry
creations, snails and spirals; and he found it a
little depressing that he had been keen on
food like that, even though he shuddered at
Thea Taxis's choice of bread and the indi-
vidual slices of sausage and cheese, at her bleak
taste. Times gone by. Through Maria Spielberg,
Ingbert had gotten into the circle around
Sonja. This was the way he had memoralized
the facts of the case. In his fantasies he saw
himself spending evenings with the two
Spielberg sisters. Neither Mr. Truebner nor
Dr. Kern shared in the quiet, harmonious, little
gathering that these three tranquilly enjoyed,
for as figures in his picture of the ideal they
were all of them wistful human beings, bound
together by a higher common goal, but in an
unflustered way.

In reality they were all three nervous. Maria,
Ingbert's friend, had told Ingbert about her
older sister and their old, noonday dinner
guests. At that time Maria Spielberg had by

Wohmann 25

way of exception been taking her meals at the
Department of Justice cafeteria and was among
their clientele, as was Ingbert, because her
sister had broken her little toe and for that
reason was eliminated as cook. How charming
this diminutive and yet so momentous acci-
dent had subsequently struck Ingbert as being,
how characteristic of a woman of Sonja's type;
it suited her sense of the tragic-grotesque,
thought Ingbert. It could be her own fabrica-
tion; borrowed from her own sense of humor
was also the basic concept of the accident that
in Sonja's recollection was vaguely connected
with the dog Alaska and his dish, with some
sort of acrobatics on Sonja's part while on the
kitchen stool reaching for Alaska's favorite
food and prevented by Alaska's high jumps
from holding onto the edge of the cabinet
shelf.

"The cafeteria food's dreary, I think; in the
long run it's really not healthy," said Maria
Spielberg. "I'll spend the rest of the day

worrying about my stomach, and that's going to go on now the whole week long."

"It must be the fat they use. I think it's really the fat," said Ingbert, who was at the time bewildered because Maria Spielberg was addressing him. "It could be a matter of the tallow along with the fat that they use. Years ago I had an inflammation of the stomach lining just because of bad nutrition."

"Not at all astonishing," said Maria.

"It was at boarding school, and they used tallow for frying, and that's a fact. It was in everything, always everywhere." Ingbert knew that he was talking a bit too much, but he wanted to hang onto Maria.

"My sister cooks a bit too greasy for me, too," Maria offered. "No way to talk her out of that, but in spite of everything it's wholesome, and she would never use this stuff, what did you say, this beef tallow, or is that what it is?"

"Yes, I'm sure, tallow, beef tallow," Ingbert answered very eagerly.

From their place in the line before their
food was served they both looked sick at their
stomachs in advance at the compartments with
the offerings of the day, and then they sur-
veyed with equal pain their meals on big, three-
part, square plates. Ingbert, however, felt as if
he were acting a role; for he really had never
noticed before that there was anything the
matter with cafeteria food. And to be honest,
he had to admit he looked forward each day to
the noon meal, today to sloppy noodles in the
main section of the plate, to the little meat
cushions, these fried lumps that reminded him
of an old sofa pillow, of their crocheted cases—
pillows of this sort lay all over at his landla-
dy's—and happily he made the association with
the cold, bare cheese and sausage items that
now he did not have to consume, and he was
even pleased with the little pile of wretched-
ness made of cucumbers, slippery, green, drip-
ping wet, an insult to the art of salad making
and the cook's revenge for his particular fate.

For Ingbert was certainly no gourmet, but he liked to eat. He was often afraid that he went around with an expression on his face that looked questioningly after food and drink. There were people, after all, whose physiognomies harbored the desire to eat. Didn't Mr. Truebner look like that, it occurred to him later. An aperitif? A little piece of cake, please? Where can a person relax with a decent piece of meat? Oh, certainly, there were people whose faces were engraved with these questions.

Because Ingbert knew well at the time how to share Maria Spielberg's fear of stomach upsets, because he feigned illness and patronized her willingly and deeply, and, in the days following the time spent standing in line together, had always sat at the same table with her and cleaned his plate—no, not cleaned it completely; in order to impress her, he had followed her lead and, alas, had had to leave vestigial traces behind—because he had been able to identify other suspicious additives

besides the tallow, preservatives, malevolent compounds, hence because he gave the impression of an injured party, he was enrolled among Sonja's regular guests on Wednesday.

But how does a person get a place in the evening, too, Ingbert wondered, and one day he knew the answer. It was easy for him not to play the universally superior person around Maria Spielberg, and so he did not need to master any pride when it was a matter of a relief measure: He was stuck on something he was writing.

It was going on five in the afternoon, and he was pacing back and forth in his room. A little further thought—that would bring him near to the field of vision he was seeking, and from there he would have to set his trap. He likened himself to a hunter—no, even better, to the dog Alaska: He smelled the tracks, yet hesitated deliberately in a delaying action. The coveted goal would be within reach in the

evening on the first floor at the Spielberg sisters'.

Since Ingbert was no friend of surprises—he himself did not enjoy having people take him unawares while he was being idle—and also because of his good upbringing, he called them up to ask whether it would disturb them very much if he looked in briefly, and it refreshed him inwardly that he had said *look in*.

Sonja Spielberg preferred the winter sea-
son, but only because, when it was cold,
no hesitation separated her from her three
turtleneck sweaters. Since her throat was no
longer what it should be, Maria's envy only
made her more partial: Sonja was thin, Maria
otherwise, and the two weren't getting any
younger, as the official designation for the
boring fact that they were getting older ran.

Look in! Whether he should? Oh, well, all right. Sonja was muttering to herself in this way. Now Maria appeared again in the living room they shared and had on a different blouse and wore over it her new, checkered jacket.

So, with Ingbert about to come, in the evening, and too extraordinary as well as at least a decade too young for them both, especially for Sonja, Maria was able to come to terms with the situation more successfully. Come to terms! That was not Maria's attitude toward her friend's wish to show up here at their house in about a half an hour. She carried a small, empty tray into the kitchen. She came back without the tray. She looked rosy and undecided.

"Do you think we should offer him a sherry, Sonja?" she asked an octave too high for the casual air she wanted her voice to achieve.

"Sherry or whatever, however you think is right, he's *your* friend, isn't he?" Sonja answered.

"Curious, curious," said Maria.

"What's curious?" Sonja asked.

"Your manner, I don't know exactly," said Maria.

"What about it?" Sonja asked.

For a long while she had only been pretending to be occupied in filling out the blanks on a health insurance form. Perhaps it had something to do with the terrible nuisance caused by this bureaucratic jocularity that she had gradually become really irritated. Perhaps it was less a matter of Ingbert's improvisation, of Maria's little jacket and little blouse. Sonja composed herself silently but emphatically in her innermost being—where exactly was that: in the pit of the stomach? She rubbed the knuckles of the fingers of her left fist over this bony area of her ribs, over the wool of her sweater; there was enough room there, thin as she was. Other women of her age could bury their hands there amidst glandular stuffing. Quiet, quiet, she said to the delta-shaped arena

in which feeling and intellect, sense and sensibility came in contact with each other, in that alluvial plain...

But Sonja just did not share Maria's notion that in the company of younger persons one became rejuvenated.

She liked the old men. One day—about a year ago—she had been struck as if by lightning by a suspicion: She had no idea at all what those two old men had done during their past in the twelve Nazi years. It could happen to her that, absentminded as ever with shopping and running around in the streets, she regarded all people as the same, more than phantoms but with just no thought at all applied to them. And therefore, likewise: no suspicion. But then something awoke in her, and she said to herself—probably because someone jostled her or had made an old, much utilized facial distortion thrown fiercely in her direction—could have been an air-raid warden, could have been in one of the women's

organizations, someone who harmed my par-
ents when they offered opposition in their daily
lives. Nevertheless, at that time Mr. Truebner
was denounced for deficient discipline and, so
much Sonja believed she had understood, put
into a lower pay bracket. And in what way Dr.
Kern's political and moral escutcheon was
clean, she had not retained, but she remem-
bered that it *was* clean. Yes, she liked the old
men. How they were able to manage, and how
well their constantly simmering rivalry also
became them, how competition kept them
alive, and their courtliness, their not particu-
larly clever bombast in their endeavor to el-
evate themselves above the dubiously suspi-
cious mass of the rest of humanity. In order to
achieve that, the characteristics of a conven-
tional manner and style of dressing and of
associating with other people really had to
suffice. Certainly old men of this style found
scarcely anyone nowadays from whom, by daz-
zling them with their bygone renown, some-

thing like respect could be coaxed. Sonja thought: Compared with Mr. Truebner and Dr. Kern her two most recent catches—these vigorous youths who were surviving an amateurish but open-handed way of eating—had a real advantage.

"Let us assume this notorious story-book fairy should appear and ask me for the three things I wished for the most," began Dr. Kern.

Did she really like these conversations, Sonja asked herself. She found them pleasant. She did not feel flustered within the enclosure formed by such little phrases shoved from one person to another.

"I personally," said Mr. Truebner, "I have never occupied myself with such things." He poked around a little more excitedly in his stewed fruit. Topics of conversation like this arose at dessert time, and he acted a little jealous of this notion of Dr. Kern's, probably because the effect on women like the Spielberg sisters was a sure thing. Maria had even let go

of the dog Alaska in the middle of searching
for a tick in the skin around his neck, which
amounted to a great deal, meant a whole lot of
attention paid to the doctor. "You'll all be
astonished at me. You'll all declare me crazy,
when you hear how I answered the fairy."

Mr. Truebner thought it rather inconsider-
ate that the doctor had combined two activi-
ties with one another, his indulgence in the
fruit in his mouth and the spoken word. A
strange cheek pocket came into being in the
left half of the doctor's face, and Mr. Truebner
did not let it out of his sight.

"If I had these three wishes free to use," Dr.
Kern spoke now, cheered on by Maria
Spielberg, who said she was too curious to
wait any longer. "Well, then, as the first I
would naturally ask for eternal bliss, whatever
that may be, and I would find out some day,
wouldn't I?"

"Oh, how lovely," Maria appeared just about
to clap her hands, but she let it be, for a

constant girlishness—and under girlishness, shyness was understood by the noonday guests—always curbed her exuberance except toward Alaska. With the dog she occasionally let herself go, both old men found that to be the case.

"Now come the more whimsical wishes. And the first of the two..."

How suspensefully he did that once more. The damage Mr. Truebner himself received by virtue of his want of ideas he compensated for with an unobserved spoonful of the Creme Chantilly. The little bowl had not been near him for a long time.

The doctor lifted both his arms, bent them at an angle, waved his big, fat hands as they hung suspended, striving for the portrayal of a fluttering, flying body.

"I would wish to be a bird. I would like to be able to fly through the windows of apartments." He laughed, and a chorus of those around the table accompanied him.

"It gets even more foolhardy," he reported, "for I'm a sports lover without any talent for any kind of sport, but bicycle racing is my passion."

"Strange," muttered Mr. Truebner. "It's my understanding that, wherever you look, all this frenzy for sports leads these days to rowdyism and mental sluggishness."

"Has nothing to do with the frenzy for sports these days," said Dr. Kern, who had no reason to be insulted, for he was secure in the good opinion of everyone, with the exception of his contemporary, and that was just as it should be.

"So, in short, so that I don't bore anyone…"

"Oh, but you're not doing that at all," Maria cried out, and her sister only mumbled, but it sounded like support.

Dr. Kern proclaimed, this time in the pose of a bicycle racer, as if he were participating in a charade, "I would like to race through the

finish gate as the winner of the Tour de France
Really strange wishes, most assuredly. But
storybook fairies certainly don't expect some-
thing sensible."

"I think it's wonderful," Maria declared be-
fore she busied herself, somewhat disconcerted,
with the hair on Alaska's neck.

And Sonja looked at her aquarium, as she
perceived it from her comfortable visual angle.
Sonja regarded the two goldfish unquestion-
ingly as masculine, she did not know why.
When they swam around each other, which
happened regularly, the one looked at the other
without sympathy but with forbearance, and
neither one could do without the other, that
was quite clear. Sonja often made it a point
not to miss anything about the goldfish, even
the blink of an eye. Actually, she imagined
that both became a trace more goggle-eyed
when they met. She had once kept two dwarf
lobsters. An observer could be profoundly
mistaken about the state of their emotions.

Their relations with one another had some-
thing ceremonial about them. Japanese, Sonja
thought subsequently when she had made the
acquaintance of the films of the great director
Ozu, were the flourishes of the hooking move-
ments of their pincers; they practiced so much
polite display and seemed to like each other,
so Sonja assumed. But one day her dwarf lob-
sters turned into fighting samurais, and from
the to-and-fro of the dance there evolved mur-
derous tactics. Without any desire to do so,
Sonja became a witness to their deadly rivalry.
Maria had cried on that evening. Sonja, how-
ever, experienced a certain release. The short
life of the two shelled warriors revealed so
much logical consistency. These deaths struck
her as clean and clear, so still and so painstak-
ingly achieved, so self-contained.

Now suddenly she could not answer the
question as to her own three magic wishes. All
the others had thought of something, and
should she now, in order that her lack of tal-

ent at fantasy would not disturb the conviviality, subscribe to Mr. Truebner's third wish, that he might secure new members for his Society for Cultural Refinement?

"I always know only what I decidedly do not wish," she confessed.

High time for coffee, wasn't it? Yes, of course, it was time, and she escaped into the kitchen, where she reflected with something of a guilty conscience on why she had not conformed agreeably to Mr. Truebner's relief action and said: "Oh, of course, yes, above all I wish that the two world powers should not attack each other and our beloved Europe turn into a rubbish heap." Something of that sort. She could have acquiesced. It was, after all, really in accord with her convictions, too. But why did she feel that she would not have expressed her main wish that way? The eternal bliss, on which Dr. Kern, against all expectation, was so intent, that mattered more to her than war and peace. And still, even this future

eternity was not exactly what she mainly wished. There should be, she thought, there should be something else before that. But what? She laughed to herself while she poured in the water; and with constant devotion every time to little, old, favorite jobs, she watched the coffee as it bubbled up and subsided into the filter when she poured in boiling water. She laughed because she enjoyed remembering Mr. Truebner's reaction. The doctor had taken him and his wishes to task a little. Magic wishes ought not be so very contemporary, not so sensible.

"I think the doctor is right, that should not offend you, my dear Mr. Truebner," Sonja heard her sister Maria, who undoubtedly concealed her main wish, something in connection with Alaska, something out of the way and very lovely.

Mr. Truebner said: "Agreed. I am too un-skilled at this game. Well, besides, I enjoy learning. What is it that Anton Pavlovitch

Chekhov says: 'The smart man learns, the stu-
pid one likes to distribute information'."

And the doctor, stopped short in this way,
had immediately parried, but still could not
quite make up for his setback: "I'm not quite
sure if that isn't a Turgenjev quote."

All these little altercations prospered bet-
ter when the young man, the chief administra-
tive assistant, Ingbert Wagner, was not a mem-
ber of the party, Sonja thought. And now it
did not elude her that a more important, se-
cret wish of hers had to do with this self-
inflicted dilemma. With an emotion. Oh, why
brood about it? Rather she returned to the
others with the dishes on the tray.

And from one very ordinary Thursday on, Ingbert was allowed to appear at the Spielberg sisters' in the evening also. Before he had eaten in the evening. He could come. He enjoyed the evenings much more even than the noondays' fellowship in Sonja's squad of boarders. Her evening guests did not give the impression that they were subscribing to advantageously reduced terms. An ancient ex-pianist, whose past fame still surrounded him

with glory, sat in the big wing chair in the middle, constantly chewing because until his departure he continued to be occupied with some sort of remains in his oral cavity. Sometime on some fine morning I want to ask Maria for his Hungarian name —was he Hungarian? Wasn't he Russian?—I want to be able to address him accurately for once, Ingbert resolved; but on the other hand he was enraptured by Sonja's nonchalant style. She "improved" proper names. Was it intentional? A game? Did she do it out of boredom? Alas, her life was often boring, Ingbert supposed, and he wished Sonja Spielberg would at least find him, him personally, to be not uninteresting. But how expressive, how significant and eloquent were her yawns! Something a little near to borderline took place, the border of tactlessness, Ingbert thought then, but he treasured it because it always seemed to refer to Mr. Truebner—and then she said Mr. *Truebener* or Mr. *Truebel* to him—or the doctor—and

she called him *Kernig* or *Dr. Korn*—to their
tediousness, their appetite, and all the pleas
for the defense that were dedicated to it.

However, she addressed the old pianist cor-
rectly, only Ingbert did not exactly catch the
word after *Anatol*. Why didn't he stay seated
at the grand piano for a longer time? The ex-
pianist made do with three or four chord grips
and one resounding sigh in conclusion. In this
way he seemed to be attacking the current
world of music. A world lacking culture. The
last true connoisseurs were wasting away or
were already dead. Removed to a man. But the
ex-pianist did not even risk prolonged excur-
sions back into his metiér before the small
audience in the Spielberg parlor that was re-
markable either because of its benevolence or
its incompetence. No proof at all, Ingbert
sometimes thought spitefully to himself, and
he considered that to be jealousy in his own
mind, and Sonja Spielberg was a part of the
parcel of these feelings. When she was attend-

ing to Anatol, she never yawned. Her face
assumed an alert and intelligent expression.
For him she could even blush. Ingbert had
noticed it. He did not like to be alone in the
room with Anatol and Sonja. He immediately
began to feel excessive. Even the procedure of
the meal changed immediately. The room
turned into a missionary refuge, just for him,
only because of him. He became a needy case—
the two were discussing Arthur Rubinstein—
and he chewed his cud—the other two were
eating Russian eggs... Then, when Sonja's gaze,
gray-eyed and beautiful, fell on Ingbert, did
not this gaze, always a little hungry for excite-
ment, ask as if from a distance, rather disap-
pointed: Ah, you! Are you still here too? How
strange!

Am I in love with Sonja Spielberg? That
would be curious. Ingbert deliberately re-
minded himself that he was, after all, already
in love with another woman, and the other
woman was of an appropriate age. And al-

though he felt so uncomfortable next to the little Sonja-Anatol team, as unbecoming as a boil on the forehead, the hitch in an originally good idea, he remained sitting in the rocking chair, where he felt his need to bob to and fro was ridiculous and uncontrollable. He was heavy of spirit. He thought he looked clumsy. He found himself to be unattractive, believed himself to be hardly marketable, actually as if he were some merchandise, an ill-starred bargain humbled by discounts, humiliated by repeated cuts in price, not to be disposed of, resigned to the next remnant sale. What shall we do with that package there? Sonja's troubled gaze on him, as he gave the rocking chair another push.

"I won't go there anymore, I'll end the confusion of this enigmatic self-abasement," Ingbert threatened himself halfheartedly. "Just today, but after that it's finished." His resolution wavered as he happened in on an evening when there was no guest there except himself.

Only Mrs. Lambrecht, the tenant of the mansard apartment, would probably arrive around nine o'clock, ten minutes before a particular quiz show came on. She and the Spielberg sisters were also interested in listening to radio programs—always when they consisted of intellectual guessing games. They sent their solutions to the stations on postcards, and they played bingo as well. Also something really crazy, Ingbert thought, or perhaps he sensed that these little rituals of participation anchored other people and qualified them for more than just survival.

"Everyone is to serve himself," Sonja directed. She put her legs up on the love seat, snuggled deeper into an old crocheted afghan, shoved Alaska's dark-brown, inquisitive muzzle away from the edge of the sofa, and ate pistachio ice cream out of a package. They were all free to go into the kitchen, where they could provide themselves with bread, sausage, cheese, sweets at will, completely unorganized, with

the doors always open, the bottles never closed, some tea on a hot plate, and this whole state of affairs—a nonchalance that was closely related to sloppiness—should really have irritated Ingbert. He asked himself accordingly: "Where is my irritation?" No, it didn't irritate him, nothing did on these wanton evenings on the Spielbergs' ground floor; it agreed exceedingly with him, an adherent of the methodical. Meanwhile, Ingbert confirmed how very much he treasured the Spielberg version of the Bohemian life; even more, he frankly exalted in it. The food supply, always adequate, furnished this disorderliness with a basic middle-class essence. It made Ingbert very happy that under Sonja's management everyone was guaranteed more than enough to eat. The woman he was in love with ate only at the table, at firmly established times, and very little. When he went to a restaurant with her, she read the menu in silence. Ingbert considered, pondered, conferred. She, however, dis-

closed her decision only as an imperative to
the waiter. Then, when her plate came, it was
up to Ingbert to induce her to listen so that
she would not immediately, after the first bite,
lay her knife and fork down on the edge of the
plate and prop up her arms, her chin resting
on her fist contemplating him, and only there-
upon involve him in a wearisome discourse.
He could not endure detailed narration while
eating. Just now he was using the dusk of the
television to enjoy Sonja's profile. All of a
sudden she reminded him of a movie star. A
lovely and remarkable nose. And as the light
increased, a star's pearly hair. How very much
it pleased him, and how it moved him, that
Sonja's hair was becoming gray! Now he caught
the scent of ancient times, which seemed like
an awkward and unsteady stroll in his own
imagination. How very amusing, how interest-
ing!

* * *

"Please don't invite the young man to come anymore," said Sonja to her sister. But since she was opening a can with her new electrical appliance as she spoke the words, Maria did not understand a thing. Sonja repeated her request, but this time she chose the form of a declaration: "The person who is really always a bit annoying here, who remains a foreign element, is this chief administrative assistant, your friend, my little Maria, isn't that so?"

"He's crazy about you, I know that for certain," Maria answered.

"Oh, nonsense," Sonja said, but she believed it. She did not need to be told first by Maria.

"He's too young," she said.

"I'm not old either," said Maria.

"He's too young for the others," Sonja said, "and for me along with them."

"Not for me."

How stubborn, how refractory, of Maria! Sonja was astonished at her sister, who was by nature meek. With her back to Sonja and bending over the sink, Maria said to her now raising her voice above the tap water: "He doesn't come because of me, Sonja. He comes because of you."

"May be, and that's exactly why I'm against it," she answered.

"You aren't flattered at all? Not at all?"

"No. Not at all. It's a strain on me."

"But it's really fascinating!" Maria drew the word out. "Fascinating!" she repeated an octave higher. "It's fascinating! Such fascination, Sonja! You yourself find often enough that everything here with us is a little stifling or—how shall I say it? I'm not talking about the plants—garden variety. You say: How boring life is! Sonja, those are your own words, I know it, for it provoked me so the time you spoke them, oh, yes, it did!"

"How solemnly you do go on," said Sonja.

At that Maria turned around toward her but, while she was drying the silverware, she did not look at her sister.

"What does that mean: It's a strain on me? What is that supposed to mean? Is it a strain to be admired?"

"Shall I be honest?" Sonja asked.

"If you absolutely must and if it's not something horrible, go on," Maria answered.

"Take an example: I was finding it very pleasant simply to look the way I look; you see, since I got rid of the Eusoc and only a few children still come for lessons...listen: I've enjoyed that. Over and over in the course of the day, I've said to myself: Old lady Sonja, enjoy it to the full, you can be the way you are, or—have become, can leave your old jacket on, can leave absolutely everything the way it is, no poses anymore, no pretense, over and done with all the preventative measures, all the damnable tactics. There're advantages after all to growing older, only: You have to

accept it. Take my hair, just my hair. I have absolutely no desire to give any thought to it."

"What are you talking about anyway?" Maria was gradually getting a little disgusted. She was finished drying.

"I'm talking about hair color," said Sonja.

Maria cried out in inspiration—not loud, but warily, for she knew her skeptical sister: "If it's that, Sonja, I can reassure you about that, for he told me he likes gray hair. You know, it was like this—I've forgotten the exact occasion; by that, I mean I've forgotten the woman's head…the hair we were talking about, Ingbert and I, I think it had to do with someone he works for…"

"Don't get yourself confused," Sonja warned.

Sonja was chopping up raisins and peanuts, her special treat for the tamest among the birds that came up onto the porch.

Maria stood idle at the table in the middle of their spacious kitchen. She had it in mind to suggest that Sonja—if she really was brood-

ing about the color of her hair—wanted to
please Ingbert Wagner after all. How could
she express that in the most casual fashion?
Wasn't there something vexatious heaped up
all around this topic, making it resemble a pot
roast decorated by Sonja with little mounds of
vegetables?

"So, he's not of no importance to you after
all," she said finally, though she didn't con-
sider this sentence to be particularly clever.
"You're wondering…"

"According to Karl Marx and Thomas
Hobbes, a certain amount of respect from oth-
ers belongs to the basic needs of man, or who
told me that about whom? Anatol, probably
he did; we were discussing the alleged equality
of man. You know, Anatol just suits me better.
At my age a person should seek out the com-
pany of even older people, preferably of the
very old. Well, and now I'm going to take my
noon break."

Sonja appeared to be in a good mood, but Maria was still uneasy. As she walked around the block with Alaska on Alaska's route that was determined by favorite smells, the reverberation of her sister's closing remark preyed on her mind:

"Let it slowly steal away, Maria, without any dramatics, but just let it stop."

And why did that prey on her mind? In her childhood Maria had envied her sister because she was already grown up. She stood before the mirror in those days and practiced making faces in order to get wrinkles. At what age did the twelve years difference begin to burden Maria with a guilty conscience? And how come in spite of that was living together with her older sister an ideal situation? Only the effect of younger persons makes it noticeable, after all, that we are not the same age; this then became clear to Maria, and she found it unbearable at this moment on her walk with Alaska to come upon a group of young people.

Suddenly she felt she might seem ridiculous as she hurried along behind her speeding dog. Make it quick, make it disdainful, she spurred herself on, but she had become aware recently how little a threatening look suited her. Possible that someone older, Sonja even, could suggest how to manage it—counting on their flabby little cheeks—if someone wished to appear severe and introverted and contemplative. When Maria arrived at the place in their walk where the dog might run free, and when her gaze fell on this scene, for once she did not breathe a sigh of relief as otherwise she mostly did. The reality was unsightly. She always visualized it as better. Did she not lift her head enough, did she only look at the area in pieces? Alaska's precinct: Mentally she supplied it with some kind of freedom. And she described it that way, too: "The landscape beyond the west side of the city resembles a strip of coastline, the hinterland with dams, dikes on which I wander while Alaska toddles up and down the

slopes. Going, I use the northern embank-
ment, coming back the southern one. In the
middle, thus between the two embankments,
the Brems flows in a channel."

Brems—and now even the name of the little
local river repelled her. She could not tell a
stranger about an outing that led along a trough
called the *Brems*. And truthfully, on this walk
along the embankment, one could not lift one's
eyes from the ground at all for more than a few
steps, for all the dog owners took their animals
out here on these rounds. The path was the
last stop in the circular track of solicitous ca-
nine care. And where else should one look
anyway? The vista out into the open country-
side, resembling an outlet onto the sea, went
nowhere at all. To the right and to the left of
the path one looked into little yards, variously
divided, thoroughly trodden and marked with
footpaths, utilized in every square decimeter.
From the rear the little one-and-a-half or two-
story tract houses were reminiscent of un-

washed underwear too long in use. Maria was forced—and she was sincerely against recognizing something so unsightly and ill-concealed—to think of old, outmoded union suits, men's union suits. All of these homemade balconies and porches had something unfinished and revealing about them, and on each of these eyesores there clung a cancerous appendage, sometimes as a wooden shed, sometimes as a stone chicken house, and dirty, yellow shelters of corrugated plastic accommodated bicycles and mopeds and all sorts of furniture. Furuncular possessions, all heaped together, no good, unsightly.

"It must be because it's winter," Maria said to herself. "It's getting time for spring. People are tired of the bleakness and of cabbage and of bare trees. And they are comfortable with their few belongings. Enough of this bitterness."

And scarcely had she given herself these orders when just then she was in luck: On the

corner lot, next to the railroad underpass
through which Maria had never yet really hated
to walk, she discovered a bush with tiny white
buds on the dark-brown boughs. Hard to un-
derstand, the world!

Could that be the key to the secret of how much he enjoyed being at the house of the Spielberg sisters: the hospitable neglect that made you feel part of the family? Ingbert knew about hospitality as an attribute that it was his weak point. His Achilles heel. His moral defect. He just could not do otherwise, he had to be inhospitable.

"My Siegfried shoulder, ha, ha, ha," Ingbert managed, for it was easier for him to tolerate

his defect if he betook himself with it to the
ranks of classical heroes. "Ha, ha, I'm sorry,"
he said to an unannounced visitor, when he
was caught in the lie that he had neither the
time nor anything to offer. That he had no
time, furthermore, did not appear to him as
untruthful at all. He lost every minute, could
record the feeling of loss physically when he
was caught unawares by other people. He
watched his own time flowing away as if he
were looking at an overturned hourglass. There
it goes, there it is, running away from my re-
serve supply—he felt this with indignation.

When the visitor had gone again, there was
a formidable amount of time to spare, and
Ingbert was not capable of any practical appli-
cation of it.

"I would so like to be hospitable, I would so
like to accept all chance happenings with ease
and good humor!" He sighed. He spoke softly
to himself. "But I just love to be orderly." He
put three newly acquired baskets of blue plas-

tic net in their place in his efficiency kitchen. He did it with loving application and, in passing, thought of the compliments and the envy his achievement would bring him, if it had not been for his more intense propensity toward seclusion, because of which the pleasant yield of human approbation escaped him.

"How will that be one day—perhaps not exactly one lovely day but certainly one noteworthy day, provided that I permit that day to be—that is, the day when the woman I am officially in love with wants to take possession of these things—I still say wants to, I do not say she will! But, really, how will that prove to be?"

Did the second key to the puzzle of the pleasure he took in the Spielbergs lie in the age difference? Ingbert responded to persons of his own age with indisposition and irritation. He supposed that this uneasiness went back to the gym classes and recreational pastimes of his childhood and youth. On the other

hand, he had actually only recently pondered over this susceptibility. Maria, at forty-one, three years older than himself, seemed to him, when Sonja was not present, to be missing an arm. And even on the way to her house on the street between the Department of Justice and Landskron Embankment, No. 94, Maria, alone in his company, appeared to him in need of completion, like a garment with only one sleeve. How come he always thought of arms in this context?

They were sitting together once again at the Wednesday noonday meal. Today Mr. Schimmelmann was also with the group, an indefatigable, restless man, not gainfully employed, who recently had assembled a theater troupe around him and his optimistically effervescing vivacity.

"It is absolutely imperative to inspire people with enthusiasm for one particular thing," he proclaimed, since it was his intention from now on to treat the gathering around the table

to his reminiscences, which were full of ex-
amples of igniting the souls of strangers. "The
infectious impact of optimism, how often I
have been able to observe it. The education of
the people is, for a man of my talents, like a
barrel without a bottom: One can obtain an
infinite amount out of it—this group, that lec-
ture course—of the pure mobilization of hu-
man competence, but someone must be there
who sets the fire, in a manner of speaking, who
brandishes the spoon, haha! For, left in peace
and to themselves, men, as they crouch within
their four walls and don't know how to move
forward, resemble grain in the hull, and con-
sequently it is necessary finally to bring these
grains—to stay roughly within my metaphor,
you see—together with each other at last, and
a type of porridge emerges; that is the humus
in which something can be made to grow, and
someone wields the spoon, stirs the porridge..."

How did it happen that Mr. Schimmelmann
concluded somewhat haplessly? He seemed to

recall his plate and, relieved and also a bit contrite, he partook of a forkful of mashed potatoes and a lettuce leaf. With that he finally dislodged the dog Alaska. Alaska had been sitting to the left of Mr. Schimmelmann's chair during his discourse and in reproachful expectation counted on a morsel from his plate. This now settled the affair for Alaska. He gave up his incognito and made off to the most reliable spot for begging, between the chairs of his two mistresses. Ingbert enjoyed so much watching Sonja's sleight of hand, her stealth and agility in the style of a magician, these truly illicit techniques with which she provided for Alaska at the table. Directly above the trembling black nose of the animal she quickly opened her fist and let the food fall into Alaska's snapping range.

And now, fortuitously, a meeting of her eyes and Ingbert's resulted, and Ingbert savored her curious, lovely laugh, resembling a brief faintness. A very private communication

about slightly devious conduct. About something compulsive. Why do I like so frightfully much to feed so secretively this dog, who is really not so thin? Maria was not represented in this alliance, although, after all, during their meals she, too, furnished Alaska with little bits from her plate, using ruses of a similar style.

"The light out there today is really not typical winter light," said Ingbert in a loud voice. He wanted to make an impression of reassurance on Sonja. He wanted her to find in him an expert among the initiated. And she always liked to hear that spring was at hand. Winter was loathsome to her. She had perhaps forgotten that last time she had already introduced him to her winter bloomer, the magic nut, and what that meant was: She had gone across the whole garden with him to the fence that bordered the neighbor's lot, where, to the right of the compost heap, there bloomed her bringer of joyful tidings, the first bush in the

garden showing a sign of life, honey yellow on a commonplace brown stick.

Sonja answered him and he was disconcerted that she sounded so grumpy.

"Winter light, summer light, spring or fall, you must be pretty bored with us here, my dear fellow."

"Why should he be?" asked Mr. Schimmelmann. "I consider him to be a person capable of enthusiasm"—he directed his gaze at Ingbert as if he were seeing him for the first time and in him a new type of cellar louse to be molded in a flash by a partner in the story of creation into an amateur actor for his theater troupe. "Really, I see much that is positive in him," he concluded and in doing so seemed pleased, untruthful, and disappointed in one breath.

"What do you mean by that?" grumbled Sonja. "Would you care for more vegetables?" She shoved the dish without an exact direction. "Spring or not, winter's end, sunshine

...sun, moon, and stars... I do not enjoy living anymore, oh, my heavens, now I have mis-quoted Hölderlin or some other high-powered poor devil, haven't I? Isn't that so?"

"Yes, you have," answered Maria sternly. She looked angrily over at her sister.

"Bravo," Mr. Truebner called out inatten-tively, for he couldn't see why Dr. Kern should again hook the best catch at the second round of the plate of fricassee. "In case this plate should have the grace again to favor me..." he began, and he got the plate; Sonja pressed it a trace too expressively into both his hands.

"I am not bored! Not here, never here!"

Finally Ingbert found the opportunity and the strength for contradiction. He drew a breath and started in: "It's the company of older people that is good for me, or the com-pany of really old people; it's that more than the food, delicious as it certainly is, more this intellectual climate than anything else that really inspires me here."

"Bravo," Mr. Truebner called out again, and it was not clear whether he meant Ingbert's statement or his own success with the fricassee. Ingbert, however, felt humiliated and slightly ill. The manner of speaking of the other men at the table obviously must have seeped into his consciousness through some unavoidable infiltration, otherwise he could not explain to himself why his own sentences from his own mouth nevertheless seemed to come from a stranger. And Sonja? No thanks came from her. A bitterness enveloped Ingbert.

"More younger people should adopt your attitude." This was the judgment of Mr. Wittmann who, like Mr. Schimmelmann, was at intervals a regular guest. On the strength of this he submitted the idea to the Spielberg sisters that they should extend their board to his young nephew from the coming month on.

"It would be good for him; he prowls around strictly with those of his own age, the young

twerp. And you, you would have another pay-
ing guest."

Sonja received payment of not clearly de-
fined sums by the month and also gifts for her
hospitality. Ingbert did not believe in the fair-
ness of this method of exchange, but he looked
on impassioned by it when Sonja took the
money: With a preoccupied look on here face,
she appeared half negligent, half reluctant,
and then she said hurriedly, "Oh, yes, yes in-
deed, right, thank you." And without inspec-
tion she accepted what was humbly offered
her.

On the following Wednesday Sonja took revenge on Ingbert and said: "I can understand only too well, I think, that someone would prefer the company of persons who are older than himself." But Sonja's perfidy only took hold of Ingbert's mental faculties when she had added: "And therefore, my dear guests, please do not offer me any young nephews or the like. I enjoy dealing with the older age group myself—in every respect."

Maria's outburst of forced laughter did not create an interruption any more than at other times, but Ingbert showed mute respect for her sensitivity. Maria often attempted to soften the blatant remarks of her elder sister. But Ingbert found nothing needed to be done, nothing to desire. It was just exactly these eruptions that he liked and this lack of self control.

Sonja was a woman who read books in a recumbent position, always several in rotation. And such books! She confessed openly and to arouse disapproval that she liked trash and rubbish, and she liked best of all to read old-fashioned young girls' books. Instead of priding herself like the rest of mankind on finishing something aimed at her serious advancement as a thinking being, she mumbled, "I have read *The Major's Daughters* incessantly. And then these passages in *Winnie the Pooh*, summer-weather passages, and gardens, every possible kind of flower, Maria, we should have

mignonettes, too. And heliotrope, glycinia, too."

"But we do have them, precious, dear!"

Sonja's only object was to provoke the others. Ingbert knew that, and he saw himself as the one particularly addressed. Why, certainly, it was meant for him. Now at his cue he was supposed to speak up, and dutifully he said:

"If you remember, we talked about this already, these garden moods. You get those from Gottfried Keller really. He was the one who used the phrase 'homesick for gardens'."

The other dinner guests had long before agreed that Sonja was depriving herself of something critically important by renouncing all connection with youth, but none of them was successful in appearing not to be flattered.

"Besides, I would have problems with the stove," said Sonja. "I don't have more than four burners, after all, and no bigger pots and pans either."

"You know very well you have the roaster—
you know, the enormous, oblong, cast-iron
roaster, dear sister," said Maria.

"That heavy thing," Sonja muttered.

"It's become fashionable again to cook with
cast-iron utensils, such pots and pans you see
everywhere, too." Maria was making an effort
to liven up the circle.

"Quite excellent, quite excellent," Dr. Kern
unbosomed himself, not without smacking
noises, and a little vacuously.

"And you, too, my dear Mr. Wagner"—Sonja
looked at Ingbert for an exceptionally long
time—"you are also too young for me."

"I can well understand that, naturally,"
Ingbert answered, although it was more for
appearance's sake.

"I can count, after all," Sonja replied.

"Did you really go to sleep again, I ask
you...did you go to sleep again after six-thirty,
darling?" Maria asked her sister.

"I don't know whether I was sleeping, but I had my mouth open," Sonja said.

Ingbert had to make an effort to tame his enthusiasm. Remarks of this intellectual origin, of this quality of mind, made him happy, they unlocked something within him, they amused him. An open mouth as evidence of sleep! How inventive! It vouched for a self-reliant inner life. But the courage of an independent mind manifested itself still more in that Sonja revealed herself to others as a person who lay in bed with her mouth open. And she had to know how little the other men were won over by such acknowledgments. No applause. Not for a woman of just over fifty, who did not shrink from speaking of pendulous face muscles. All of their jawbones fell upon their chests during every noonday nap, and probably every one of them snored according to the impersonal laws of human throat and larynx harmonics, but didn't the civilized nature of the waking state protect this very

same human creature from candor in the use
of language as well as in confessions them-
selves? For this confessing was neither oppor-
tune nor productive. One took one's snooze
and gathered from it new strength for the next
contribution to the socio-humane constella-
tion in which one was personally involved.
Done, finished. Sonja's guests mostly did not
sleep well at night. Mr. Schimmelmann's sleep-
ing problem was mastered when, in the middle
of counting sheep, he stumbled on anecdotes
from his many colorful fields of volunteer ac-
tivity. The lambs' pasture changed into a bio-
graphically plowed field. Mr. Schimmelmann
always discovered something and with luck
was inspired anew: Curt Goetz, a vast field, at
that time not worn out in Baden-Wuerttem-
berg; and wasn't there a play about him with a
female lead who supplied the title? In such
reflections he could slip off confidently into a
new phase of sleep. Mr. Truebner took a good
book in hand.

"Probably it's only over *good books* that a person can fall asleep quite quickly," advanced Sonja.

Now she would—if no one else got in her way, which she had nothing against, for she would have preferred not to take part in the conversation—now she probably would once more have to throw into the discussion a few of the titles of her favorites from the waste-land of her reading delights that were totally immature and also educationally lacking.

Ingbert ventured an observation that was meant to get the drop on Sonja, so to speak:

"Your favorite books, young girls' books or how should I know what this species used to be called, they come, after all, from a time when you yourself didn't even exist; that's true, isn't it? I only mean to suggest by this that somehow you like to represent yourself as older than you are."

"But it seems to me as if I really did live then," said Sonja, and this time it sounded in

earnest, and Sonja looked blissfully happy. "At
that time, in gardens like those, under a tree,
best of all under a linden tree, pleasant sum-
mer shadows on the nicely covered table with
at least two aunts visiting and a father who
was the bishop's advisor or, if you like, the
major in *The Major's Daughters*. He smoked a
meerschaum pipe, represented the conserva-
tive-liberal point of view, and was a little scorn-
ful of the women at the table—there were at
least two rebellious ones at the table—but he
liked to take a stroll through the City with
them and bought them something conserva-
tive-liberal in a fashionable shop, preferably a
stole, and in the garden they would swing or
lie in a hammock, yes, that's the way I really
must have lived, if things were as I recall
them…"

"You're dreaming, of course," Maria cried
out. To the others she said, as if she were
giving information to a doctor's retinue on a
visit to a sickbed: "It wasn't so different, I

mean, not completely otherwise from the way she tells it. It was certainly a bit uncommon at our house, at one time, seems as if it were longer ago than it was."

It was a dreary Wednesday, this time. It was raining a little. The heavens, too, gave the impression of being distracted, thoughtless. The day's rain was like a case of sniffles that was not worth paying much attention to. Of the heavens, as they were today, nothing clear could be discerned.

Dr. Kern was complaining about a tiresome buzzing in his ears. Mr. Truebner was agreeing completely with Mr. Wittmann: The weather reports were becoming less and less dependable. Dr. Kern could not help it, but whether he wanted it or not, from time to time a huge, universal suspicion plagued him. All the things they were doing with outer space, the technicians and the scientists, there was no such thing as proper provision for Planet Earth's

salutary future. The winter months in his
memory had been more dependable.

"A lot of snow, good as far as I'm con-
cerned, we never had in this southwestern part
of our country, not a real abundance of snow
like the Bavarians. And still, February was
February, cold company. At carnival time we
shivered all over in our costumes."

"If only they would bother to beg our par-
don in the slightest way on the day after for
the wrong forecast on the day before, these
weathermen," scolded Mr. Wittmann.

For Mr. Schimmelmann the weather was of
no concern at all. He had hit upon the idea of
a new book series while in the Special Events
Center, Clubroom #4, in the multipurpose hall,
and called it—working title, he said—"Read-
ing through Pictures." Pictorial documenta-
tion of the life of Friedrich Schiller had, you
see, fallen into his hands. It didn't have to be
Schiller with whom he would open this series,
but illustrative material like this could, after

all, with some persistence surely be found in the personal records of other great men also, stored away somewhere or other. Most felicitous would be to present the public with a Swabian who was also a playwright of this type, picture after picture, with little narratives provided under each one.

Mr. Truebner was quite concerned with the weather day by day. He always consulted the calendar of the previous year when a winter day appeared to him all too mild.

"Everything has happened before," he informed Dr. Kern.

Maria Spielberg now courageously brought into the conversation the devastation caused by spray cans.

"Don't forget the multi-national industries," said Sonja, who meant this to be bitterly humorous, as Ingbert realized.

"It's a matter of indifference to you, or am I mistaken?" he asked her.

"I'm not indifferent to anything," Sonja answered. "I only feel ignored."

"You're not so helpless as you pretend," Maria contradicted. "It's just more convenient for you that way."

It happened very seldom that she attacked her sister. And for that reason she immediately looked around the table in distress.

"What I mean to say is this," she explained to the others. "My sister suffers immensely when spring cleaning takes place every year on the neighbor's lot to our right. Really, and instead of talking to them—they're not monsters, after all…"

"It's not a question of whether they're monsters," Sonja cried out, but immediately comforted herself by aiming a morsel at Alaska's obliging nose from the fist she quickly opened.

"My left foot is hurting me, and that's all," she said, as if that offered a universal explanation. And Ingbert felt himself influenced. This information affected him like an official gov-

ernment declaration. With that, even the topic of the weather was declared disposed of.

"Sometimes a person would like to get hold of all the top politicians on earth, the whole business is so shabby, from the weather to aching feet, and the mangy, miserable, rat-faced next-door gardeners included."

Seldom did they hear Sonja talk like that.

"You'd better take some more of the medicine for your rheumatism," Maria said softly.

"Sure, sure," said Sonja, "I'll take my controlled substance, and if that doesn't help, then I'll look up my doctor and he'll give me an illicit injection, isn't that the way..."

"She's talking about the Food and Drug Administration," Maria explained.

Exasperation and vexation! Ingbert suddenly felt the full burden that Sonja Spielberg was subject to. And in spite of it, to cook so well for all these ill-tempered old bachelors! Ingbert perceived his infatuation again as curiosity about the eccentricity of this living

human being, about the quite unique Sonja, who had so petulantly decided against her youthful reserves. She aimed at appearing elderly and whimsical. But he had to provide a contrary effect—and, in fact, on the spot—with some kind of defense tactic. At the table in the meantime there was lamentation about the laxness of doctors and the lack of any basis for confidence in the use of drugs, during which only the completely unfazed Mr. Schimmelmann abstained, just as he abstained in regard to the pharmaceutical trade; according to his view an individual felt well as long as he really wanted to and was involved besides in the production of enterprises embracing life, and Mr. Schimmelmann would, at the first possible pause in the conversation, grab hold and begin to talk about amateur theater.

"Enthusiasm, optimism, and along with that a sensible life style with physical harmony, joy in the fruits of our culture, these components..."

"Will always fatten the beef." Sonja finished
Mr. Schimmelmann's tirade, but Mr. Schim-
melmann never looked annoyed. He nodded
in agreement, though not completely pleased.
Ingbert looked out of the window that faced
to the west. The first cherry tree was bloom-
ing! How come he had just noticed it? A little
while ago, except for the rain that was remi-
niscent of a drippy nose, Ingbert had noticed
nothing. In the visible segment of the little
front yards, otherwise dark everywhere, strictly
speaking, ugly, and a piece of the street and
the stone wall confining them, all united in a
theme that was forbidding, the little white
tips on the cherry tree branches were reminis-
cent of tiny pieces of clean laundry come there
by mistake. They looked as if they needed
protection. They had never yet been touched.
But in this assemblage of unsightliness they
would, of course, be hurt. The rest of the scene
promised nothing good; it promised nothing
at all. But that small onset of blossoming there

in the cherry tree, thought Ingbert, that speaks in a different tongue. Should he translate it? For Sonja and right now, Ingbert spurred himself on. But how? Out there, just look, a harbinger! How fatuous. Ingbert, already fearing for his first momentum, longed for an inspiration. Something ingenious! That's what he must find. I stuff myself with too much red cabbage, Ingbert chided himself. No wonder he couldn't turn the right phrase. His mind was bogged down in his stomach. Whether the languid vegetable, inky and gleaming, in the dish with the faded gold rim was called blue cabbage, red cabbage, or kraut, whatever name that did justice to what Sonja offered them, that was what they had been arguing about just now in the manner of old, satiated, gluttonous, hotheaded, half-dead boys. That was Ingbert's judgment. He would actually have liked best to get up immediately. He would have grabbed Sonja by the shoulders and cried out, "Come into the garden with me. There is

something amazing to see there. Let's just get away from here, and fast."

"Those surely can't possibly be morels, these little black pieces in your excellent sauce, my dear?" asked Mr. Wittmann.

"Mushroom substitute," Sonja muttered, "and I don't taste anything anyhow."

"It's really first rate," Dr. Kern supplemented the praise of his table neighbor Mr. Truebner, though with poor articulation, that is to say, spoken through the food he was chewing.

Such insolent answers as she was giving today. Ingbert found Sonja grimmer than usual. So—he would not say anything overwhelming about the cherry tree. Maybe like this: There! Look! The tree is suddenly blooming. Nothing sensational. It is, after all, perfectly natural in the most correct meaning of the word. Obvious, a tree has to begin, and then it continues again as every year: blossoming, prospering, bursting forth, and gleaming... Sonja's ham-memelis—but he liked to hear her say Magic

Nut better—came to Ingbert's mind, and his place in line was already sacrificed. He would only come in second after all with his discovery of the cherry tree. The record purloined, the round lost in this competition of affirmation. Better to nip this silly spring nonsense in the bud. Ingbert was not going to talk about better times that would ostensibly come. Sonja would probably intervene anyway with her terrible neighbors who, with their contamination of every vestige of nature in their search for practical application, could in no way be disconcerted. And wasn't the white bespattered cherry tree ridiculous, too!

Maria tried in vain to convince her sister that she should make a new attack on the ear-nose-throat doctor. Sonja, who could taste so well for everyone else, got scarcely anything out of her culinary artistry herself; at least she maintained she could not judge if her green salad was really as well seasoned as the others maintained.

"When the good fellow, this doctor, said it was problematical"—Sonja made a grimace— "I knew then: Nothing to do about it. It was of no interest to him anymore."

"And the pills that are not controlled," Ingbert exclaimed with vehemence in order to seize upon this, "I just mean, these uncontrolled pills, you needn't take those at all because they have no effect anyhow, and that's just the reason they're allowed. No effect without side effects."

Would something about the cherry tree possibly fit in here? What did its side effects consist of? Would it be clever to say: The tree resembles an old-fashioned gentlemen's vest, out of whose little pockets tiny dust cloths are hanging—oh, no, first, vests like that with so many little pockets didn't exist at all and, second, Ingbert considered it a completely false note that in order to compare a tree with blossoms to something else for a pretty garden fancy, he had hit upon that particular line of

men's furnishings and that he obviously did
not escape old gentlemen and their appear-
ance even in the contemplation of nature's
wonders.

Mr. Truebner admonished, "At your age,
my dear friend, I didn't even know what pills
were. There could be no question about them
at all."

The others at the table, if their memory did
not betray them, had fared the same.

Ingbert watched his own face, fortunately
covered with dust, in the mirror at the back of
the glass case, his pleasant, hazy face, as he
said:

"Dear Sonja Spielberg, with all your pessi-
mism, which I well understand, you shouldn't
interpret this remark of the doctor's, this *prob-
lematical*—he made a little face now, too—
"too fatalistically. But I assume you do it on
purpose. You make it your object to represent
yourself to us again as ready for the scrap heap."

What if something impudent, at least forward, is at the same time useful? Sonja pondered. Ingbert had pleased her too well just by getting her number and putting her in her place. To relieve her sister, Maria usually carried the dessert in. But this time Sonja had not followed this game plan. She needed a breather—that's what she called it. Pears with walnut custard were on the program. Two dishes stood in readiness. But Sonja paused never-

theless. The absence of excitement in her
present life. That was what she had in mind
when she decided on the company of older
people. The absence of cheerfulness, she sud-
denly corrected herself. Cheerlessness was
something else. She did not know if it was
something more favorable or something far
less favorable. The absence of something. That
diagnosis was better. Oh, her silly face that
had gotten so hot. A little mirror was over the
sink, and Sonja looked into it, and she said
with quiet aggressiveness, intending to insult
herself, "Burning cheeks! Disgusting! Red and
blue cabbage cheeks! Dumb Dora!"

How nice that at the next glance—and it
was aimed at the bowl of pears and the cus-
tard—how very welcome that her reliable ap-
petite for sweets came over Sonja. And actu-
ally, two and a half months after her sinus
infection, she was gradually able to taste al-
most everything. The sisters came off very well
with their table companions inasmuch as, in

spite of all past experiences, their guests could not prevail against the soups and main courses. They had to eat their fill beforehand and had only the remnants of appetite at their disposal for the dessert.

But the Spielberg sisters did not help themselves to large portions of the beloved sweets for all that; they did not fill their little bowls full to start with. At first they rather took too little. It happened hastily, resembled the stealthy method of feeding that they employed with the dog during the humans' mealtime. They acted like two thieves and were like guests in their own house. Sonja's tactics amused Ingbert. Now she was speaking as if she wanted to simulate a completely different personal commitment, but the true topic engaging her—Ingbert knew it—was at the moment the custard.

"Between doctors and patients something like with the police would have to take place. I'm thinking of police patrolmen. You still get

enough of that in English novels, don't you? I
mean, doctors would, in a manner of speaking,
have to go on patrol, look out for their pa-
tients on their own. A patient in his helpless-
ness and embarrassment should not be forced
to alert his doctor at the risk of having him
dismiss everything as a trifle."

"Well, no thank you," said Mr. Truebner.

And the other old men also had better
things to do than to doubt their vitality.

"Aren't you being a little hypochondriac,
my dear?" asked Mr. Schimmelmann.

"But she really avoids doctors," Maria ex-
claimed.

"That could actually be because I am a
hypochondriac, little sister," said Sonja.

Ingbert liked the way Sonja turned the des-
sert spoon over in her mouth; the spoon came
out of Sonja's mouth, as she sucked it, with
the bottom side turned up; it amused him. But
what was it in all these little attendant ma-
neuvers that illustrated her nature and yet at

the same time disguised it? What was it about them that made him so happy? If Ingbert fished Sonja's association with sweets out of the multitude of things about her that gave him pleasure, then he could, in his happiness through observation, be dealing with a type of homecoming—like a snapshot: click, click— back to his own childhood spent eating sweets. His landlady, with her cast-iron optimism, she could have drawn a custard spoon through her lips a thousand times and still in vain—but Ingbert attempted to eradicate this image from his mind immediately.

It helped him to think of Sonja when, alone in his room, he brooded over the bleakness of the world. She freed him from it. He stepped more easily and without a fit of anger over the sill into his shower stall, and he made the best of the crazily howling noise that greeted him when, as if he were imitating Sonja, he sang along in order to offend the ventilator. You had to laugh at them, these ridiculous situa-

tions that people made for themselves. Ingbert stared with tempered despair at his latest model toilet. He felt Sonja's support. She would laugh and groan along with him about the grotes-queries and pretensions and about the lack of the imaginative in everyday life, and the two things would be the same, the laughing and the groaning.

In earlier and more proper times Ingbert would have considered himself engaged to Anne Spohn. She was the woman he was in love with, when he pulled himself together and thought about it; he certainly had been, for sure. He did not understand exactly how Sonja had interfered with that. Anne Spohn lived as yet in Biskastel but was moving in town soon, and Ingbert remembered his mis-sion—to be on the lookout for an apartment suitable for two persons with the need for space and the desire for individual lives—about as regularly as he remembered that he had to brush his teeth at least once a day, and once a

day he did it, too, in the evening, when it was
not difficult to take good intentions seriously.
From morning on I will worry about it more
profoundly; I will announce after brealfast: I
will brush my teeth. Anne Spohn. Anne.
Annie. Ingbert made an effort. It was not just
the capital city that beckoned, no, it was prima-
rily Ingbert whose proximity Anne sought. She
worked in production for different publishers,
freelance worker was what she was, and there-
fore not tied to one place. It was clear, it was
quite obvious, Anne and he, they had to man-
age this change of habitat. No one had hinted
up to now that there was something the mat-
ter with the progress of their nice and fine,
meaningful relationship. Anne visited Ingbert
every weekend. Recently he felt her presence
so spatially. She seemed to him to be so large.
She filled up space. She takes away space.
Ingbert didn't want to express it that way when
he thought of her. On the other hand, after
her departure on Track 3 and on his way back

to the apartment, he felt like someone who
had visited the seashore and on his trip home
notes: I really didn't see the ocean at all.

Ingbert picked Anne up at the train—ev-
ery weekend. To persist faithfully in his habits
was his custom. If only this were faithfulness
itself. Anne looked pretty—that was an essen-
tial point—and there it rested. Kissing her was
fun, although you couldn't smoke or drink or
eat subsequently because your lips got creamy
and perfumed by the coating with which Anne
protected her skin from the climate. For too
long a time—so Ingbert thought—she had not
desisted from the habit of twining Arabian
scarves around her neck. He observed these
scarves with growing distrust. In fact, they
always looked good on her, but Ingbert would
have wished for a little more sense of humor in
Anne, and from that sense of humor would
have come reserve as well as self-criticism—
that was about the way he thought of it. The
political signal, the scarf as a beacon, Anne

wore alternately in blue and in red, a check-ered adornment, Ingbert, who for some time had been going around inwardly angry with her, discovered. On the other hand, how much it was worth, after all, if one enjoyed taking a grown woman in one's arms. And it was worth a lot, too, that in the course of time Ingbert was managing his nerves better: He no longer waited for Anne for half an hour on Track 3; rather he learned to arrive there almost unpunctually. His adaptation to living grew in proportion to the amount his anxiety over the timetable of the Federal Railroad oozed away

This time Anne wore the Arabian scarf on her head and knotted under her chin. She kept it on in the room, too, though at any rate draped around her neck.

"Everything is always so frightfully neat at your place," she said. "Let my cup just stay here, will you, here on the table. Come on. We'll clear things up later."

How come, Ingbert asked himself, I didn't notice from the beginning how hard it is for me to endure it when she looks at me? Why is it I can't manage this being stared at? Ingbert had difficulty with Anne's way of almost sucking in his eyes with her eyes. He felt like a dog from the animal shelter. He was under observation for the time being. The decision by a potential owner to adopt him was dependent on every little movement that the dog, deserted and somewhat cranky as it had now become, would make. And exactly in this he now saw his chance.

He moved his low armchair a good distance away from her little place on the sofa. An impolite distance away from her.

"I'm awfully farsighted, you see," he said and immediately found his motive for moving away from her to be too reasonable, too easy to understand. Hardly any offense to be interpreted.

"I'm not comfortable standing or sitting near other people," he added.

"And lying down? You're looking forward to later, aren't you?" Anne asked, and this time he was displeased not just by the way she smiled.

"Do you think women should be like that?" Ingbert asked in return.

"What do you mean—like that?"

"Insinuations of that kind, I'm not positive whether..."

"Positive is just what you are not ever, that's the sore point. You aren't that—positive—and on the whole actually. And there we really have the truth."

Anne stood up and paced back and forth in the room, but as if she were waiting for stage directions. Someone else who was not positive. Amateur theater. Dilettantes and their lusterless awkwardness. Feeble in expression and nevertheless vain. The emotions themselves had something clumsy about them. They

remained foreign to the actors. Ingbert actu-
ally had to think of Mr. Schimmelmann with
fondness. He was doing the right thing to force
the inborn clumsiness of men into the care of
plays staged temperately but nevertheless with
fervor and to propel onto the stage any nobil-
ity at all, which would of necessity be mis-
placed in the lives of these people. And from
thinking of Mr. Schimmelmann, the way to
Sonja Spielberg was short.

"That's the truth," Anne repeated, but prob-
ably she had lost her train of thought: Just
what truth was she talking about? She received
no new orders from any higher theatrical au-
thority. Her cue was Truth: In order to find
something on the subject—so it appeared to
Ingbert—she was now leafing through the tele-
phone book. Then in the slips of paper that
lay next to Ingbert's telephone. She was doing
that only as a distraction. Nothing secret was
on those slips, and still it aroused apprehen-

sion in Ingbert. All at once every object in his apartment seemed treacherous to him. And was this feeling really disconcerting to him today for the first time? No. For several weeks the presence of Anne Spohn had taken on the nature of surveillance.

Don't snoop around here! And if there's any talk of truth around here, that was it: A while ago, when I pretended to be farsighted, I really mainly wanted to move farther away from you!

Ingbert was very good at being rude in silence. But outwardly politeness kept him from being at risk. Say something absolutely stupid, he might well have implored Anne, for all along his great chance lay in counterattack.

"Please be nice to me again," Anne said then, and Ingbert's courage sank. "Everything will get better soon, when we don't have just these few weekend hours with each other," Anne went on. She busied herself now with her Arabian scarf, then with Ingbert's slips of

paper, and the situation appeared to be so bogged down, so far from the miracle that might presently happen, that Ingbert's throat was affected by surprise when Anne brandished one of the slips and cried out: "What's this awful thing you've written down here?"

Ingbert would not have credited his collection of papers with so much impact, although he felt himself spied on through and through under Anne's gaze. Anne read aloud to him, her voice sounded guttural from indignation, and Ingbert was a little disgusted that, as happened from time to time in the case of special emphasis, she reverted to the Frankish dialect with the labial R pronounced trillingly:

" 'I need few, I need one, I need no one at all.' Ingbert, what does that mean? I ask you, what kind of trash is that, really!"

"That is Montaigne, the great French philosopher," Ingbert answered, as he experienced the light of grace shining on him. Now take hold! He gave himself the whip. Go on, don't

let the reins drag! He would like to have said:
What is nothing but "trash" to you, the hu-
manists agree is a philosophical pinnacle, is a
magnificent work and a jewel, irreproachable,
far and away above the common, dull garb of
hangers-on and the civic minded and the bab-
blers and chatterers. Blabbermouth! Fad-fet-
tered with your partisan babushka on the aca-
demically bourgeois prosperity of your head
or, rather, your little head. You trivial, oh, you
common and obvious...then he felt sorry for
her again, crushed by Michel de Montaigne
and Ingbert, and: Did he really not need "any-
one at all"? Again he valued very highly the
cigarettes that Anne, near to the border as she
was situated, procured for him every week in
France, and the moment would really be arriv-
ing very soon when she would unpack a carton
and a half.

When this time, too, with Ingbert as a witness, Sonja projected onto the television screen a confusion from the four available channels, she knew what she was doing. In rebellion against it, her purpose was to demonstrate that the specter of dependence was not there, and already she was threatening the colorful pictures—now of the Engadine—with the switch. Thereupon a moderator sat among juveniles in a studio, and Sonja was enjoying

herself. Very soon, by switching channels, she
was going to make the moderator and his guests
ridiculous. She was plainly exercising her power
over what was offered by these managers of
men, these television dictators. With her pic-
ture language she communicated how irrel-
evant and ridiculous to an aging woman the
recommended offerings of life were. She was
notifying a man, still young for many years to
come, of that. She, Sonja Spielberg, remained
uninfluenced by the common, ordinary invi-
tation to participate, and her person was free
for scorn and rejection. Truly noble is renun-
ciation: Was that Goethe? And how much of
her resistance did Ingbert catch on to? He was
hanging around over by the floor lamp and was
a real annoyance. If he would only go back up
with the others. Sonja was poling round on a
colorfully navigated ski slope. Wasn't this
young man overlooking her dodges? Oh, of
course not; Sonja certainly knew that long
since no shred of Sonja evaded him anymore,

and the fact that this amused her did not amuse
her. How awkward! How much she would have
preferred not to find it too warm now, but
rather a trace chilly, as on all other evenings
when no admirer caused such excitement. In
spite of the blanket in which she was envel-
oped. Very inconvenient really, very crazy.

Ingbert exclaimed: "When you say some-
thing like that, it gives me...well, what?...a
feeling of delight really! Some of your remarks
have the effect of something that tastes
good..."

"There's no doubt that you overrate my
nonsense," said Sonja.

The way her pulse was beating annoyed
her. It immediately picked up speed upon
Ingbert's effusion. How senseless, how farci-
cal! What use was it to have good sense? Your
body returned thanks for every compliment
with absurd evidence of palpitations and an
imbecilic glow.

"No idea even what I said," she muttered.

As was her old custom, she stretched out her arm to attract the dog. In his resting place under the table, the dog raised his head briefly, examined the value of the temptation, classified it as low, and laid his muzzle back down on his front paws. He continued to be offended. He was not wanted upstairs at Maria's party, and consequently he remained, not like Sonja, unwillingly below.

As if by rights he ought not to repeat her words, Ingbert said cautiously: "You said: 'Now I am already over fifty—' " He cleared his throat. Sonja had been more drastic with this passage: "Now I will soon be sixty," was what she had said—"I've already reached such-and-such an age, and still I'm always surprised when I suddenly think of something clever…" Ingbert's laughter sounded artificial. He could find no format for the perfect expression of his sentiment. Was he gasping for breath a little?

First I would have to make an appraisal of this young man, Sonja thought, and only then

would there be a certain logic to it if I felt flattered. For I do feel flattered. She deposited gumdrops within reaching distance of her left hand. In the right she now took up Jane Austen's *Sense and Sensibility*. As a result she really presented the picture of a person domestically settled and renouncing companionship.

"Shouldn't you go back up? They'll worry about you." Sonja took a gumdrop and was about to be completely impolite and pretend to read.

"It's not interesting enough without you," said Ingbert. "Everyone up there is hoping that I'll bring you up with me."

Everyone up there: That was four younger people whom Maria was entertaining this evening. And when that occurred, then Sonja was allowed to be absent. Her request for release dated from last summer: "Never again do I want to be with people who are younger than I am for a protracted length of time, Maria," she had decided after a yard party. "I'll be glad

to help you the same as ever with all the
particulars before and afterwards, little sister,
but there's nothing to do about it. I don't
enjoy it. I overexert myself, and I'm bored,
too. It's not reasonable that I waste my capital
this way."

"Everyone up there is hoping in vain," said
Sonja. "Believe me, I'm not putting on airs. I
don't want to be praised into going up. In
complete honesty, I prefer it here in my blan-
ket, etc."

She did not need to make any confession to
him. She suffered horribly from the competi-
tion and this evening also from the contest
between herself and this new entry, the little
beauty with the Arabian scarf, and that Ingbert
had said to her, to Sonja: "I can easily tolerate
your brusque nature," she considered not espe-
cially charitable.

"You're inflexible; you don't find much of
that around anymore."

"I come from the days of the Romans," Sonja mumbled.

"You season all empty conversation with some kind of tart remark," Ingbert pressed.

"It's nice that you are so solicitous of me, but please, think of me as being there when the plate with the tarts is passed around," said Sonja. "Reluctantly I dolled up every mouthful. To oblige Maria. It's what she imagines when she says it should look nice."

"And it does look beautiful, too," Ingbert commended her.

"I can't stand it, dolled up food, as I said," Sonja informed him. "Sausage with bananas, I find it more appealing when a piece of cheese means a piece of cheese and not something or other topped off in a vulgar manner with a bunch of grapes or with lumpfish eggs—in case you thought that was caviar, I'm sorry, it's not caviar."

"What are you annoyed about?" Ingbert asked.

"Be off, be off, oh, friendly, striving youth, hahaha," Sonja brought forth, and in accompaniment she made a movement with her arm as thoughto drive away a swarm of mosquitoes, but because she had the remote control in her hand and the television set was across from her, she only managed to change the program on the screen. Ingbert lurked in the neighborhood of the door. And this door leads out into the hall and from there up the steps to the second floor and the other young people, go on, go on, Sonja wanted to continue, and in doing so to remain as vocally intense as she had just been. To her own amazement. Courage worthy of appreciation. She would continue her declaration at once. Inadvertently she pressed the sound button, and the feature picture "The Treasure of the Incas" was announced instead of her own pronouncement. Actually there was nothing left, it occurred to Sonja as she glanced at the television picture and while she was not listening to the words,

nothing left that she was truly interested in. Peculiarly useless, angular, and excessively embellished, ineptly manufactured utensils flickered across the screen.

Ingbert had opened and closed the door so quietly that Sonja did not perceive in what way and with what sort of facial expression he had departed. But he was gone. She looked around after him. For a long time she felt in an unpleasant way that she was not alone in the room. Was there something that might possibly interest her after all? Ingbert's courtly admiration? In her musing Sonja intentionally used an old-fashioned word for Ingbert's wooing. Quickly she reflected on the recipe for apricot dumplings and whether there were any dried apricots to be found in the pantry.

For three-quarters of an hour Ingbert had held out as a guest among Maria's guests. On his return from a trip to the bathroom, he slipped by Maria's room to the stairway down. At this moment his Anne—still "his"—was in

the spotlight, guaranteeing a certain length of time, for they would talk about excessive rent and the rights and injustices of landlords.

Ingbert went down the stairway as if it were a ladder. He knocked on Sonja's door. He would follow his own mandate and be bluntly to the point.

"I miss you so much," he said as he entered.

It was really a frightening grimace that Sonja managed with difficulty and for which she gave herself a grade of A. This reception was identical with being thrown out.

Ingbert reached the same conclusion. A! First class! Bravo!

"Even this face, which you're making for my benefit, inspires me," he commended Sonja.

Presumably that was so, and he belonged to the tiny minority of younger men who become enflamed for women who are growing old.

"That isn't just a face; that's the way I look when I don't make an effort," Sonja yelled at him, not very loud but quite ungraciously. With

her arm extended and the palm of her hand held high, she kept him away from her. She gave the impression of a person who would like to remain in quarantine.

But Ingbert was not afraid of contagion.

"Not much longer and I'll be sixty," said Sonja.

Ingbert ventured to come rather close and advised: "Celebrate that birthday, when it comes, with humor. With your own very special humor."

"With whom? Who's that?" Sonja asked. "Sounds as if you know him."

"Know whom?"

"This character, this Humor."

"Oh yes, I know him, well enough to rave about him," said Ingbert.

Any minute now he would kneel down! He knew no proper move. Sonja, too, was stumped.

"Then keep him company, not me," she said. "Do you feel it, too, it's beginning to get boring, isn't it?"

"Are you actually sending me away out of honest conviction? And are you doing it as a favor to me?" Ingbert asked slowly. "Or whom are you trying to please by this? Certainly not them up there?"

He made a motion toward the door with his hand, appeared to be perplexed, and his eyes began to burn from the effort of looking back and forth so much.

"You see," said Sonja, "just because with my few little years over fifty I'm so pleasant and entertaining for someone who's in his late thirties, just for that reason I'd prefer not to impress anybody."

"Sheer folly," Ingbert answered.

He noticed that he was getting depressed. He saw no enlightenment. But as he was gazing at Sonja all wrapped up in her chair, the image disappeared and, instead of the woman who was navigating between the gumdrops, the television controls, and Jane Austen's *Sense and Sensibility*, he saw the cherry tree, sense-

lessly blooming all too soon, he saw it, snow-white in all the dull gray-brown sullenness of a February day in Central Europe. Ingbert was not about to leave the room and Sonja without making a comment about that little tree; that much was certain. He would have to dream up something remarkable, something suddenly snow-white in the midst of the dusk of the room.

"I don't know exactly," Sonja answered distractedly. What had Ingbert asked her? Her tongue seemed to her to be coated and too big for the space in her mouth. "That's all a matter of interpretation," she said and did not understand the connection. Whatever was he talking about, what was he reciting about a cherry tree that was blossoming? He had little idea about the things in a garden; only with the greatest difficulty did he recognize the most common plants, but he could not name even the very first wild shrub. On the whole he didn't understand anything.

And still, with the catchy words "cherry tree" a touch of pleasure at the thought of spring lay hold of her. The effort by which all of her plants would burgeon forth came upon her suddenly as an incitement. And something possessed her that seemed like the courage to look forward to the first warm evening spent sitting on the seat in the garden: Yes, quite right, to the left of the cherry tree and just under the shelter of the frail cedar that she would certainly not have cut down, sickly and brown as it was, no, most certainly not. Now, actually, what sort of summer things were there hanging in her closet?